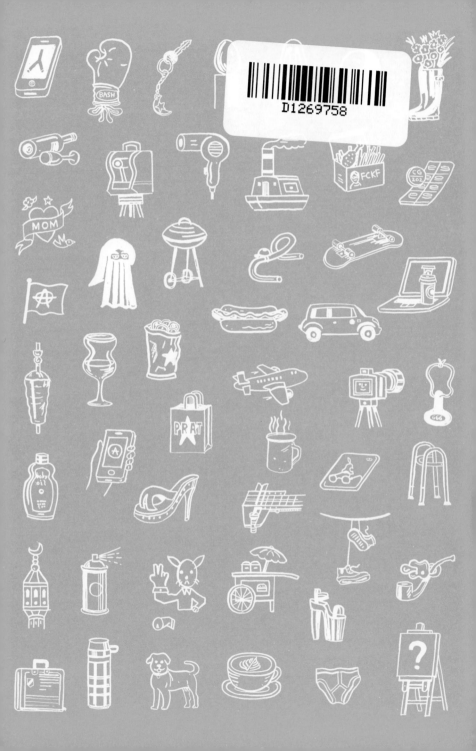

50 PEOPLE
OF EAST LONDON

Illustrations by Adam Dant
Text by Adam Dant, Martin Usborne, Harry Adès

HOXTON MINI PRESS

50 People of East London
First Edition

All artwork and characters within are Copyright © Adam Dant 2013,
except on pages 6–7 which are courtesy Bishopsgate Institute.
Text © Adam Dant, Martin Usborne. Introduction © The Gentle Author.
All rights reserved.

Artwork by Adam Dant
Design and layout by Friederike Huber
Words by Martin Usborne, Adam Dant and Harry Adès
Series design by breadcollective.co.uk

A CIP catalogue record for this book is available from the British Library.

ISBN: 978-0-9576998-1-6

First published in the United Kingdom in 2013 by Hoxton Mini Press

Printed and bound by: WKT, China

This book and associated prints and products can be ordered from
www.hoxtonminipress.com

Illustrated East London

Book One

250 collector's editions of this book and signed prints available at:

www.hoxtonminipress.com

INTRODUCTION

Adam Dant is the latest in a venerable tradition of artists stretching back more than five centuries who have portrayed the infinite variety of human life in our great metropolis in prints, chapbooks, and upon playing cards, creating sets of images commonly known as the 'Cries of London', featuring street traders and hawkers.

Spirited representations of the redoubtable female watercress sellers of Shoreditch abounded throughout the eighteenth and nineteenth centuries, and in 1804 William Marshall Craig depicted a vendor of brooms struggling heroically beneath the burden of his stock outside St Leonard's church, while in 1812 John Thomas Smith drew William Conway of Bethnal Green who walked twenty-five miles every day to sell metal spoons throughout the City.

Yet for Adam Dant, two hundred years later, the precise nature of commerce undertaken by many of his subjects is less overt, though it is readily apparent that every one is on the hustle in some way or other, but I must leave it to you to resolve for yourself the intriguing question of what exactly each of these Londoners of our own day is selling ...

The Gentle Author of *Spitalfields Life*
Spitalfields, July 2012

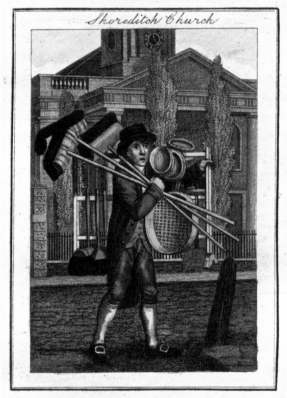

Shoreditch Church

HAIR BROOMS.

Broom Vendor, William Marshall Craig, 1804
from 'Itinerant Traders of London' – courtesy of Bishopsgate Institute

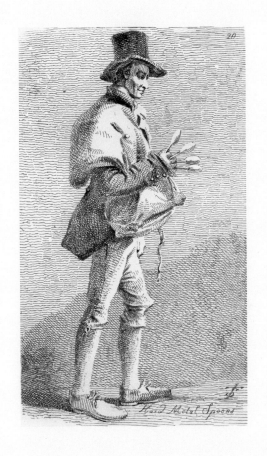

William Conway of Bethnal Green, John Thomas Smith, 1812
from 'Vagabondiana' – courtesy of Bishopsgate Institute

CONTENTS

AGGRESSIVE ESTATE AGENT

*The process of buying property in Shoreditch is
made stress-free by the pointy-haired, 22-year-old
commission-ravenous Essex boy who has the poetic skills of
a slum-messiah and the ability to make you, the client,
feel utterly worthless.*

TYPICAL LOCATION
Curtain Road, Hoxton

USUALLY CARRIES
Spearmint Rhino loyalty card

RARITY
2/10

SPOTTED

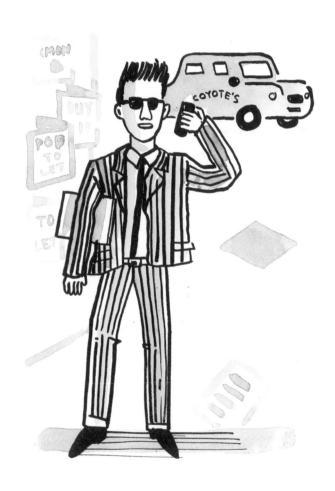

AGGRESSIVE ESTATE AGENT

AMERICAN GRAD-SCHOOL INTERN

*Don't let the extreme politeness fool you - this well kempt,
ever-smiling youngster from upstate New York who works
in a gallery specializing in late 20th century papier-mâché
phalluses will stab anyone's back to achieve promotion to
fourth assistant curator.*

TYPICAL LOCATION
Hoxton square

USUALLY CARRIES
The perfect smile

RARITY
6/10

SPOTTED

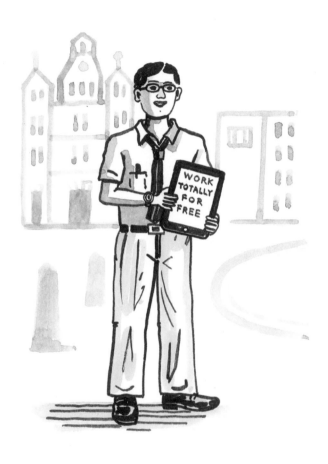

American Grad-School Intern

APP BILLIONAIRE

Wasting no time on irrelevances like sunshine and friends, Thad Fardwangler spent his 11th birthday writing an algorithm for options traders. Now 14, he owns a couple of refurbished Victorian mental hospitals in Hackney which he has kitted out with 200 ping pong tables on every floor to provide down-time for his 3,500 interns.

TYPICAL LOCATION
Old Street

USUALLY CARRIES
Nintendo DS

RARITY
8/10

SPOTTED

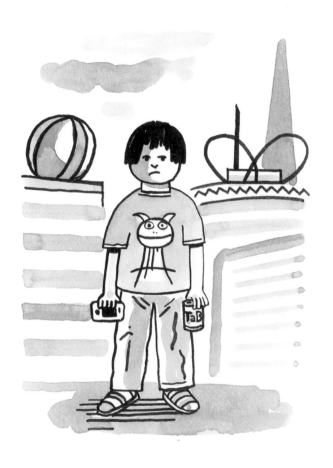

APP BILLIONAIRE

BALKAN POLE-WORKER

Back in Skopje, this firm-bodied dancer was just about to embark on a career as a paediatrician before she discovered that giving close-up anatomy lessons to a Shoreditch audience was far more lucrative.

TYPICAL LOCATION
Hackney Road

USUALLY CARRIES
2 litres of baby oil

RARITY
5/10

SPOTTED

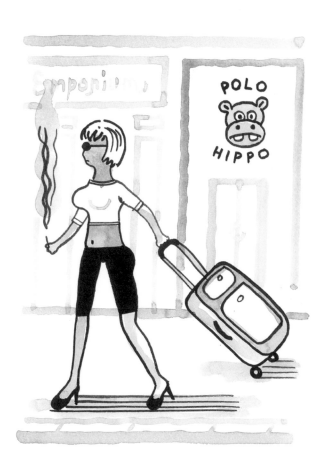

Balkan Pole-Worker

BARGE DWELLING FANTASIST

*When the sunlight glints off the half-submerged plastic
bags in the Regent's Canal you could be mistaken for
thinking you were amongst the bejewelled glories of Venice.
This ex-copyright lawyer has now found solace in the
simple life of reading the classics, wearing hemp and
buying soya latte.*

TYPICAL LOCATION
The canal beside Broadway Market

USUALLY CARRIES
Platinum Visa card

RARITY
4/10

SPOTTED

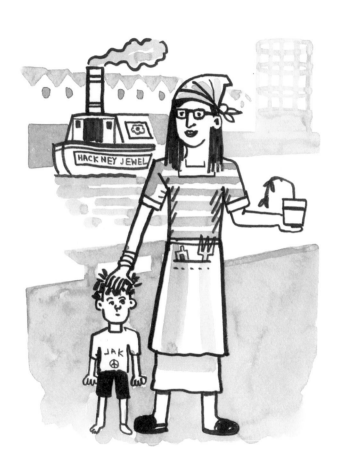

BARGE DWELLING FANTASIST

BENCH DWELLING LABOURER

*The yellow liquid in the two-litre Evian bottle under
the bench is as close to being home-pressed apple juice
as this man's 'Whack-me-sum-wonga' payday
loan contract is to being a tenancy agreement.*

TYPICAL LOCATION
Hoxton Square

USUALLY CARRIES
Last week's Evening Standard

RARITY
3/10

SPOTTED

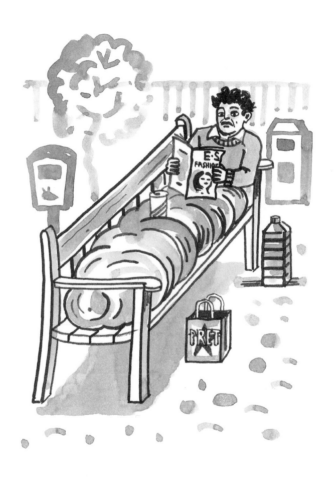

Bench Dwelling Labourer

CHIRPY BEGGAR

*The outrageous cheer from this dishevelled meths drinker
is sure to induce urban guilt and the release of a few
silver coins. When he asks for 'some spare change for
a flight to Barbados' you know he is probably not joking
despite his toothless grin.*

TYPICAL LOCATION
Brick Lane

USUALLY CARRIES
Ankle scabs

RARITY
3/10

SPOTTED

◯

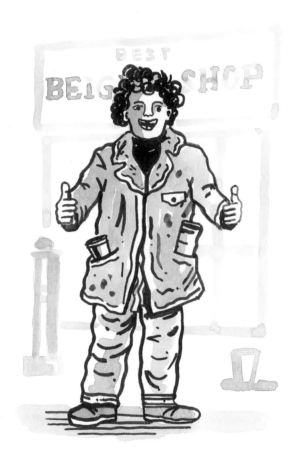

Chirpy Beggar

COUNTRIFIED URBANITE

*In mid-August the only people you're likely to see wearing
a flapping pair of mustard corduroy trousers, a thick
Barbour jacket and carrying a large rifle are those walking
up Fournier Street, Spitalfields, on the hunt for a peeling
verdigris to inspire the perfect Farrow & Ball door paint.*

TYPICAL LOCATION
Spitalfields

USUALLY CARRIES
A Labrador

RARITY
8/10

SPOTTED

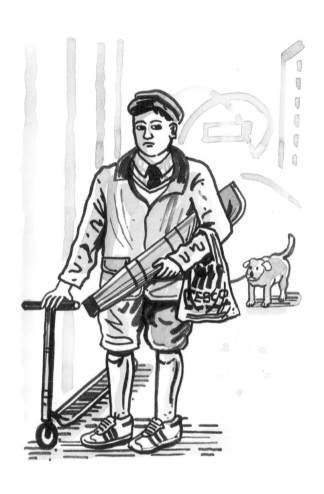

Countrified Urbanite

CREATIVE

———

*Earning £80,000 a year as a 'digital thought leader'
this man is so far ahead of the curve he has gone round
the bend: he reappropriates vintage comics as underpants
which he sells on Tumblr and recently proposed to his
Swedish girlfriend using a mix of instagram and origami.*

TYPICAL LOCATION
Great Eastern Street

USUALLY CARRIES
MacBook Pro (21")

RARITY
3/10

SPOTTED

○

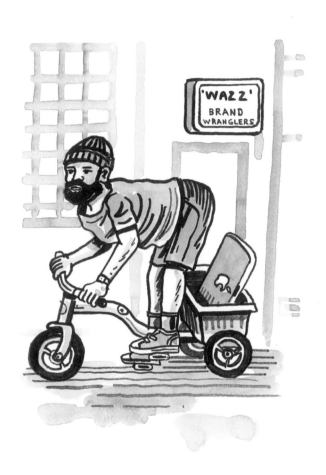

Creative

DEEP FRIED SCHOOL KIDS

Ambition for these grease-fingered poppets stretches only as far as their next batter-drenched flash-fried meal. Which is just as well, because their main contribution to society may well be as morbidly obese cadavers on a medical student's dissection table.

TYPICAL LOCATION
Pitfield Street

USUALLY CARRY
10 Superkings

RARITY
3/10

SPOTTED

〇

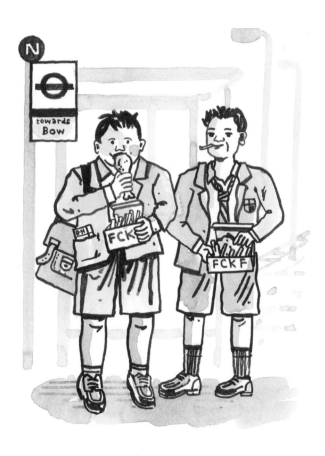

Deep Fried School Kids

ECCENTRIC DESIGNER

*With peroxide hair and goggle-box specs this middle-aged
media designer and shameless self-promoter spends
the day strutting the streets of Shoreditch in
Rupert-the-Bear trousers before retreating at night
to work on his corporate rebranding for the local
mini-waste recycling plant.*

TYPICAL LOCATION
Leonard Street

USUALLY CARRIES
Silver-topped cane

RARITY
7/10

SPOTTED

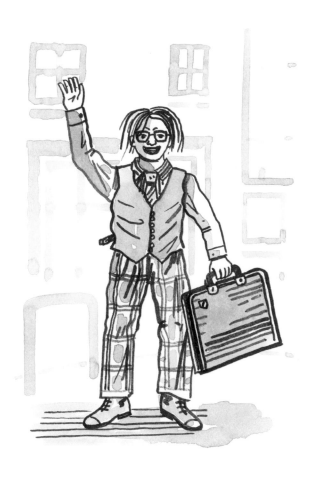

Eccentric Designer

ELDERLY LEFT-WING DAD

This ageing Newsnight producer recently moved into deepest Hackney to send his child to the very lowest scoring school with the intention of exposing her to 'real life'. He is appalled that so many other white people also frequent the local gastro-pub.

TYPICAL LOCATION
Clapton

USUALLY CARRIES
The Guardian

RARITY
6/10

SPOTTED

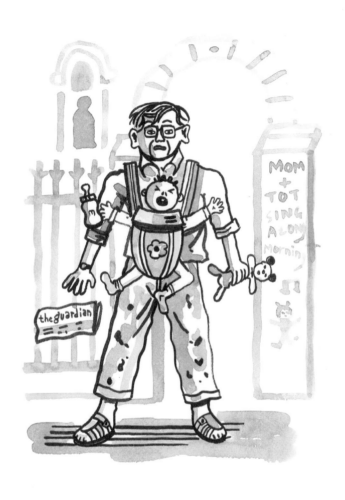

ELDERLY LEFT-WING DAD

ETCHED NECKS

———————

*At a job interview the appearance of a large cat or
creeping rose just above a starched-white collar may
suggest an affiliation to proud East London values: family,
hard graft, honesty, but in the modern office it usually
elicits the response 'don't call us, we'll call you. I presume
we can reach you on the number on your forehead?'.*

TYPICAL LOCATION
Bethnal Green

USUALLY CARRY
Bottle of ink and a rusty compass

RARITY
5/10

SPOTTED

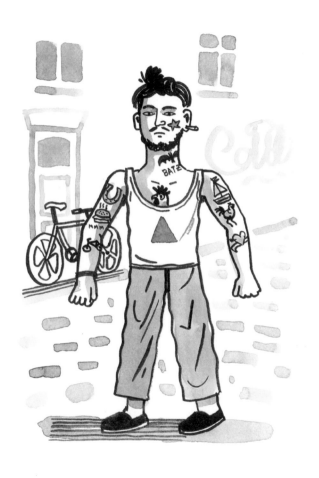

Etched Necks

FAST FOOD BARON

———————

At 11pm this master chef has the ability to serve desiccated halal tallow fried orange chicken covered in thin grease in a floppy cardboard box with a red and yellow anagram of KUFC on it and make it taste oh-my-god-that-is-soooo-good.

TYPICAL LOCATION
Old Street

USUALLY CARRIES
A field of chest hair

RARITY
2/10

SPOTTED

○

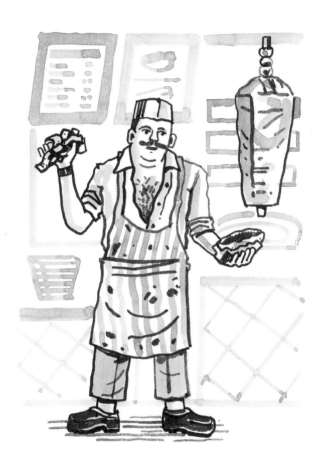

Fast Food Baron

FIXIE BIKE OBSESSIVE

———

Now that the whole world has gold-plated dildo bars how can a fixie-snob get his headset above the crowd? He outdoes his rivals by making his bike the most unrideable machine on a public road. Only one thing is more shameful to him than having brakes – being taken to hospital in a motorised vehicle.

TYPICAL LOCATION
Riding on the pavement

USUALLY CARRIES
Helmet-cam

RARITY
3/10

SPOTTED

◯

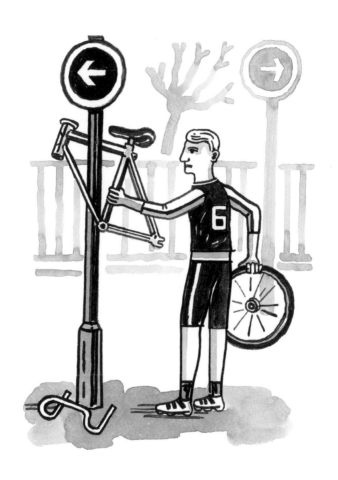

Fixie Bike Obsessive

FLAT WHITE BORE

*Don't the stubbly chin and louche manner fool you –
this barista has spent the last 15 years training in an
Antipodean, metrosexual urban enclave and has every
right to sneer at you for suggesting that your flat-white-
skinny-decaf might just be a little cold.*

TYPICAL LOCATION
Spitalfields

USUALLY CARRIES
An air of arrogance

RARITY
2/10

SPOTTED

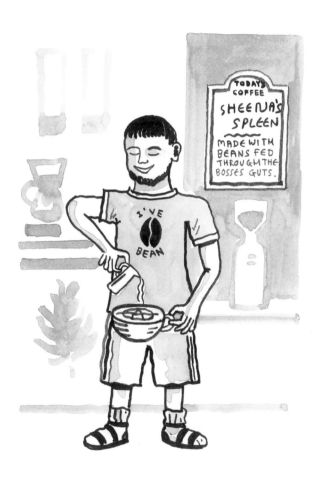

Flat White Bore

FLOWER MARKET SHOPPER

*A sunny Sunday at 2pm near Columbia Road offers the
terrifying sight of multiple fig trees walking themselves
down the road. The only clue to human accompaniment is
a cappuccino cup protruding through the foliage or a pair
of stylish boots appearing from under a pot.*

TYPICAL LOCATION
Columbia Road

USUALLY CARRIES
A massive bush

RARITY
1/10

SPOTTED

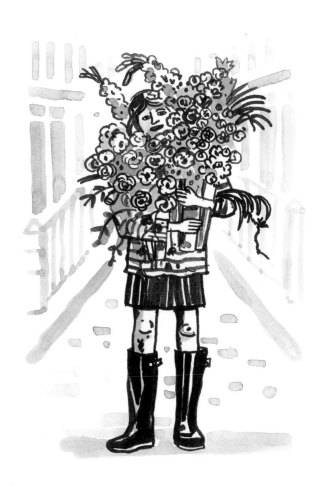

Flower Market Shopper

GENERAL DICKHEADS

*Despite their silver-sprayed high-tops and fluffy
polka-dotted onesies, these extraordinary individuals are
so unaware of their challenging presence that they possess
a certain charm. After a hard day's instagramming
they meet outside ironic old-men's pubs to shout loudly.*

TYPICAL LOCATION
Kingsland Road/Hackney Road junction

USUALLY CARRY
Vacant expressions

RARITY
Far too common

SPOTTED

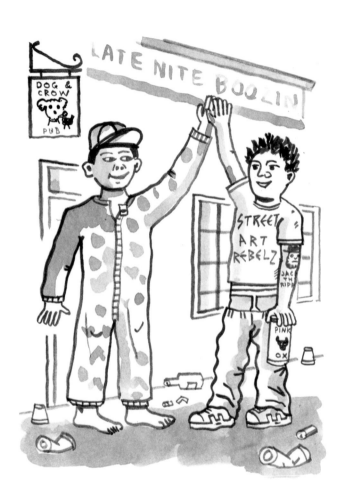

GENERAL DICKHEADS

GLOBE-TROTTING ART DEALER

Whilst East London's best artists are painstakingly translating the urban experience into sculpture fashioned from string and human waste, East London's top art dealers are in the airport business lounges of Rio, Bali and Auckland on their way to making deals with younger, more exotic talents.

TYPICAL LOCATION
Anywhere but East London

USUALLY CARRIES
Swahili phrasebook

RARITY
8/10

SPOTTED

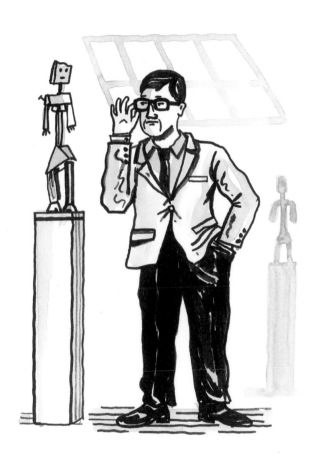

Globe-Trotting Art Dealer

GRAFFITI TOURIST

Thanks to a combination of Ryan Air, smart phones and instagram every square inch of every wall in East London is now so thoroughly documented that the whole project puts the mapping of the human genome sequence to shame.

TYPICAL LOCATION
Spitalfields

USUALLY CARRIES
iPhone 9

RARITY
4/10

SPOTTED

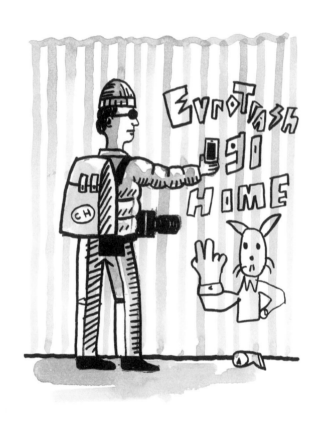

GRAFFITI TOURIST

HIPSTER BARBECUER

*When the Hackney sun shows its rare face, the
tight-trousered media-types rise at the shockingly early
hour of 11am to buy BSE-riddled burgers and frozen horse
sausages before proceeding to London Fields where
en-masse they burn ritualistic black holes in the grass.*

TYPICAL LOCATION
South West corner of London Fields

USUALLY CARRIES
Can of Red Stripe

RARITY
Medium-rare/totally uncooked

SPOTTED

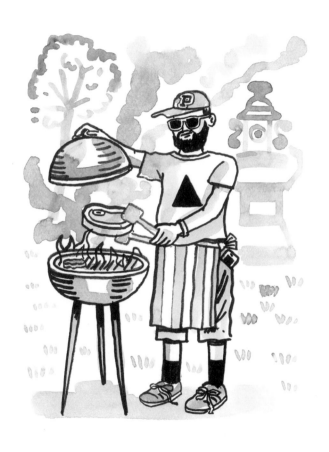

Hipster Barbecuer

HOME COUNTIES GRAFFITIST

*Known as 'Brix' to his homies but George to his
violin teacher, this up-and-coming street artist has all
the skilz to undo the establishment with his incisive
and original stencils of unusual cuss words.*

TYPICAL LOCATION
Redchurch Street

USUALLY CARRIES
Dad's lawyer's business card

RARITY
8/10

SPOTTED

◯

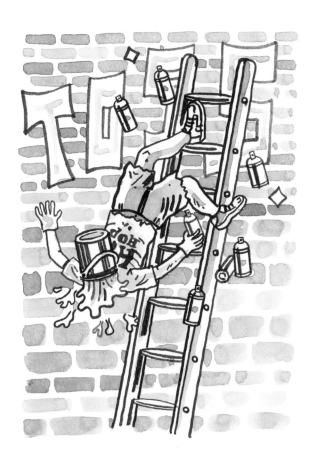

Home Counties Graffitist

HOXTON ELDERLY

———————

A dying breed – quite literally. This croaky-voiced pensioner is one of the area's few charming originals. They have spent the last 60 years watching the neighbourhood transform, all the while smoking one very long Rothmans king-size cigarette and gently effing and blinding.

TYPICAL LOCATION
Hoxton Street

USUALLY CARRIES
A pigeon

RARITY
4/10

SPOTTED

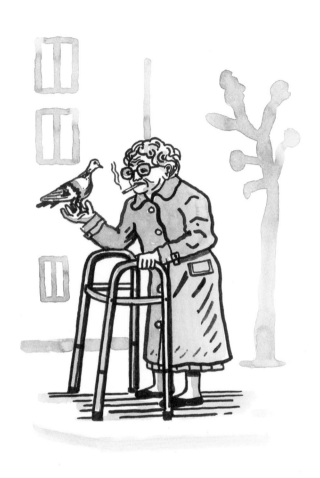

Hoxton Elderly

IRRITATING PERFORMANCE ARTIST

The average Shoreditch performance artist's 'challenging interactions' usually serve to hold up the queue in the bank or, when performed in the supermarket, prompt the repeated cry of 'unexpected item in bagging area'.

TYPICAL LOCATION
Where you least want them

USUALLY CARRIES
A platform and bag of fish

RARITY
6/10

SPOTTED

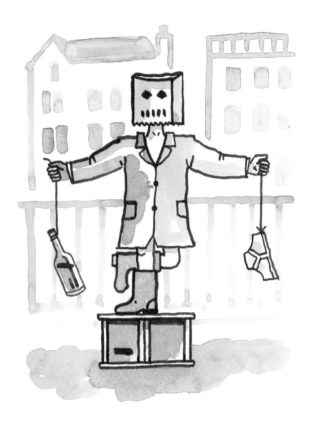

Irritating Performance Artist

ITALIAN ANARCHIST SQUATTER

The grandeur of Rome and Florence pale in comparison to the delights of a derelict vest factory in Hackney. Eschewing law, private wealth and central government, this young lady has persuaded the authorities to grant her full leasehold rights to the five-storey warehouse she broke into last month.

TYPICAL LOCATION
Hackney Wick

USUALLY CARRIES
Tongue piercings

RARITY
7/10

SPOTTED

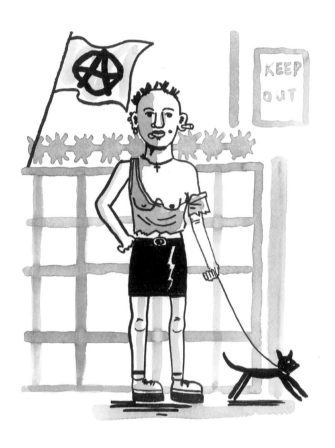

Italian Anarchist
squatter

LATE NIGHT BANKER

*A handsome bonus has not gone to waste on this
young graduate who has wisely invested the money
in his own Friday-night swaps market, swiftly
transferring cocktails from bar to gutter.*

TYPICAL LOCATION
Hoxton Square

USUALLY CARRIES
Herpes

RARITY
3/10

SPOTTED

◯

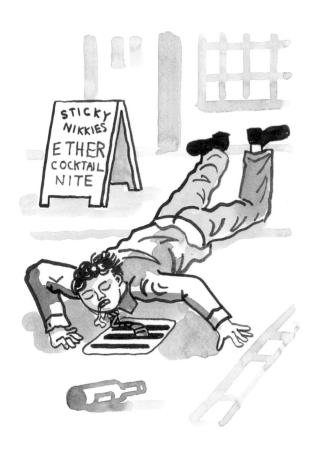

LATE NIGHT BANKER

LESBIAN SEX-SHOPPER

*The girl behind the counter of Shoreditch's best
lady-pleasure store became so fed up with being asked
'How much is that big tartan one?' that she stopped
taking her lunch to work in a 12" thermos flask.*

TYPICAL LOCATION
Hoxton Square

USUALLY CARRIES
Rechargeable batteries

RARITY
4/10

SPOTTED

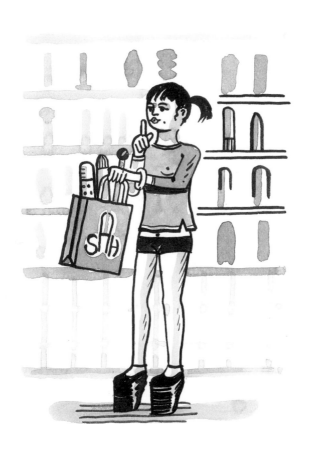

LESBIAN SEX-SHOPPER

LIGHT INDUSTRIALIST

When Reg and Butch first opened 'Fletcher and Belcher's'
warehouse 20 years ago it was ALL flanges. Now you
can't find a runcible, radial-edged, double-twisted,
triple-looped, non-conducting, variegated-semi-spatulate-
rotary-twatting-free washer for love nor money.
It's not like it used to be.

TYPICAL LOCATION
Curtain Road

USUALLY CARRIES
A beer belly

RARITY
8/10

SPOTTED

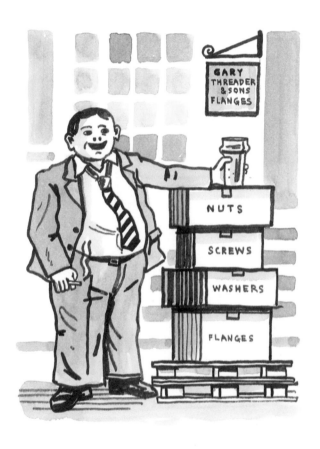

Light Industrialist

LOST DUTCH TRAVELODGERS

Visitors from the low countries who stay in London for the first time have a double shock in store: their 'hotel in the heart of London' is about as close to Big Ben as the local café's 'world famous fish'n'chips' are to being world famous...or made from fish.

TYPICAL LOCATION
Kingsland Road

USUALLY CARRY
Upside-down A-Z

RARITY
7/10

SPOTTED

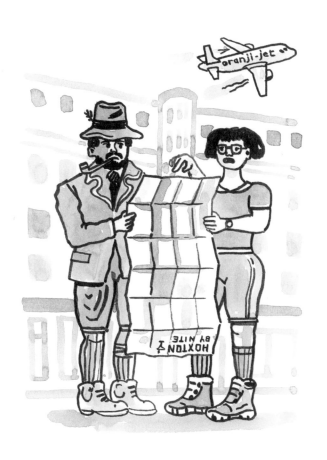

Lost Dutch Travelodgers

MINI CAB TOUT

*This charming immigrant has recently swapped
the threatening terrain of Kabul for the war-zone of
Hoxton Square on a Friday evening. He drives his
clients the longest possible route to Canning Town,
no you said Kennington, what? Kensington?
You teach me English, yes, OK.*

TYPICAL LOCATION
Hoxton

USUALLY CARRIES
No change

RARITY
4/10

SPOTTED

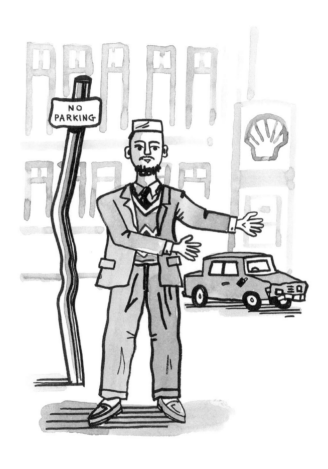

Mini Cab Tout

NASTY PIECE OF WORK

*The East End has gone to the dogs for many
embittered locals. The dogs in question being pampered
and perfumed Pomeranians, Mini-Schnauzers and
dyed lime-green Chiuhuahuas rather than the traditional
status-bestowing, toddler-attacking American Pit Bull.*

TYPICAL LOCATION
Hoxton Street

USUALLY CARRIES
The Sun

RARITY
6/10

SPOTTED

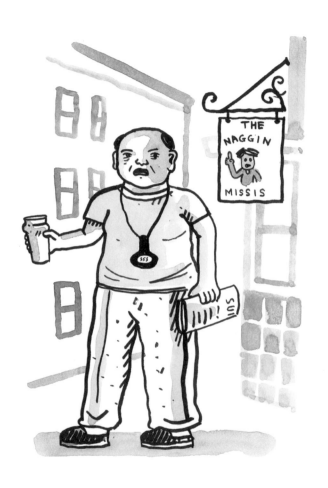

NASTY PIECE OF WORK

NIGERIAN SHOE IMPORTER

*With a loan from her brother's hugely successful
online phishing business, this intimidating woman bought
every cast-off animal-printed, befeathered, and faux-gem
encrusted shoe she could find in Lagos's seedier markets.
If only Imelda Marcos would now patronise Hackney Road.*

TYPICAL LOCATION
Hackney Road

USUALLY CARRIES
5 suitcases of high heels

RARITY
2/10

SPOTTED

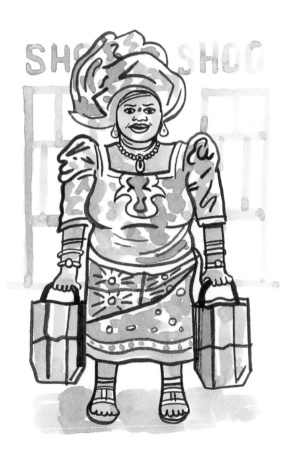

Nigerian Shoe Importer

NOMADIC LAPTOPIAN

*Why rent an office when you can migrate between
local cafés and front door steps according to the season
and sprawl your cappuccini, fashion magazines and
various blue-tooth enabled 'nodal' devices.*

TYPICAL LOCATION
Anywhere with free Wi-Fi

USUALLY CARRIES
Spare soya milk

RARITY
5/10

SPOTTED

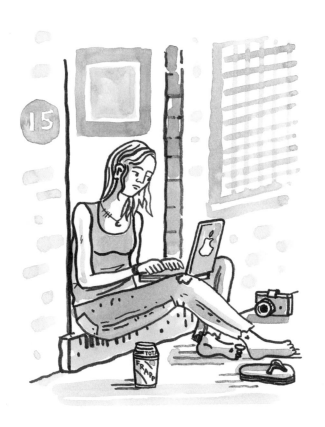

Nomadic Laptopian

POSTCODE GANGSTER

*The somewhat undernourished homeboys of Stepney
are about as 'massive' as their 'yard' which stretches
all the way from the post office to the local crèche. Don't
grass these boyz to the Feds or you may be the victim of a
serious drive-by spitting incident.*

TYPICAL LOCATION
Valance Road

USUALLY CARRIES
Concealed potato peeler

RARITY
8/10

SPOTTED

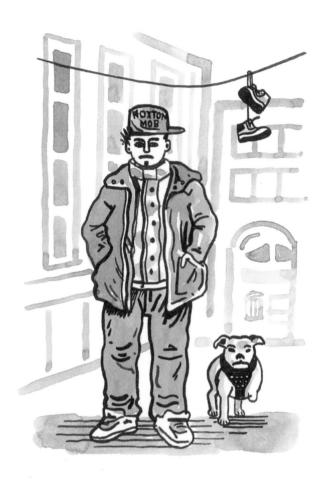

Postcode Gangster

PUBLIC PISSER

Stand clear when this cider processing plant is in range.
The stinking spray from his waste pipe squirts acrid
yellow arcs towards the nearest vertical surface.
By the end of the evening, thankfully, that surface
is his own trousers.

TYPICAL LOCATION
Hoxton Square

USUALLY CARRIES
Stains

RARITY
4/10

SPOTTED

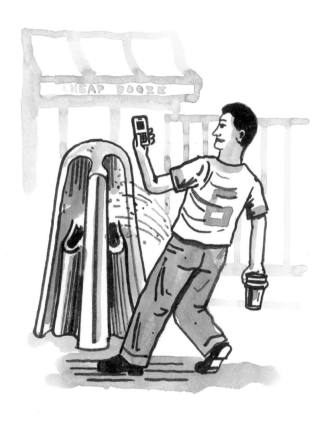

Public Pisser

RETRO-REVELLERS

*Nights out in vintage East London could be utterly
spiffing were it not for that ruddy Hitler trying to spoil
everything ... and the slightly embarrassing fact
that everyone else is seven decades ahead of you .*

TYPICAL LOCATION
Air raid shelter under the town hall

USUALLY CARRY
Gas mask

RARITY
8/10

SPOTTED

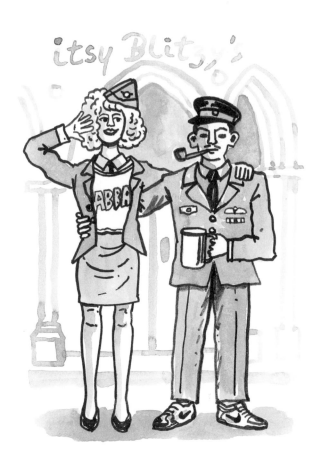

Retro - Revellers

SCREW-TOP ROSÉ GIRLS

*Now that the traditional East End boozer has
disappeared along with the discreet, elderly male drinkers
it used to conceal, the full-frontal cocktail bars of
Shoreditch spill their wares onto the street, just like
the thong-wearing, table-straddling 'city-girls' who
have become their new regulars.*

TYPICAL LOCATION
Norton Folgate

USUALLY CARRY
Their skirt in the air

RARITY
3/10

SPOTTED

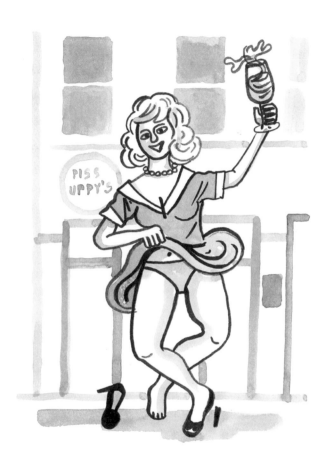

SCREW-Top Rosé Girls

SHROUDED TEENS

*The traditional hijab which is sometimes used to protect
the modesty of Muslim women is, in modern Bethnal
Green, more likely to hide a doctoral thesis on quantum
physics and a vibrant Lady Gaga dress-sense.*

TYPICAL LOCATION
Bethnal Green Road

USUALLY CARRY
Nail varnish

RARITY
3/10

SPOTTED

◯

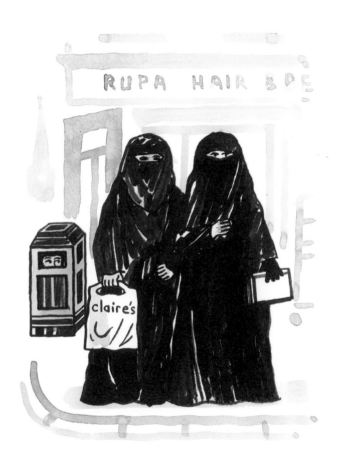

Shrouded Teens

SMART PHONE-DIVINER

*The traditional water diviner of old never had to cope
with the indignity of having their 'divining-rods'
being snatched out of their hands by some toe-rag on a
mountain bike, as is the experience of many modern
smart-phone signal seeker.*

TYPICAL LOCATION
Old Street tube exit

USUALLY CARRIES
Platinum Plated iPhone 9G

RARITY
2/10

SPOTTED

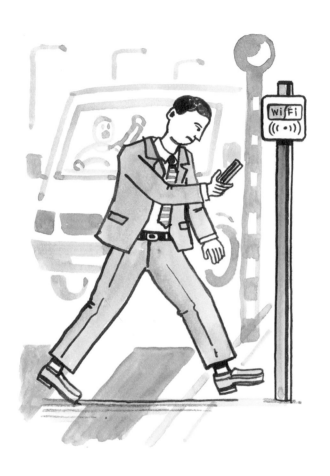

Smart Phone-Diviner

STREET-FOOD EVANGELIST

*After his gap-year weekend visit to Venezuela,
Hugo is now serving spicy tripe-soup mixed with organic
grass from a converted road-sweeper's barrow at the
Saturday market. The street food revolution will soon see
his dad's £4,000 investment return big rewards.*

TYPICAL LOCATION
Broadway Market

USUALLY CARRIES
Wooden spoon

RARITY
3/10

SPOTTED

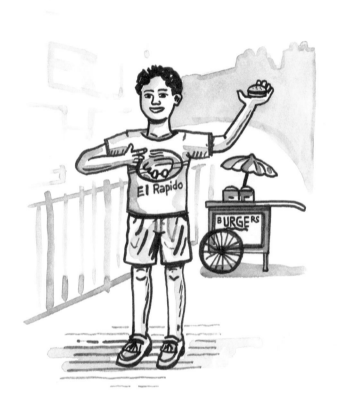

Street-Food Evangelist

STRESSED COUNCIL PLANNING OFFICER

A life commuting back and forth past the dreary semi-detached houses of East Sussex has created a mania in this planning officer. His vision of covering the remaining bombsites of Tower Hamlets with glass-and-steel erections would give even the wealthiest investor from Qatar phallus-envy.

TYPICAL LOCATION
Mile End

USUALLY CARRIES
Massive theodolite

RARITY
6/10

SPOTTED

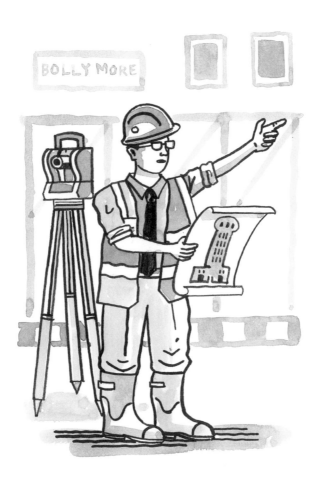

Stressed Council Planning officer

STRIP CLUB BOUNCER

The sheer volume of steroids ingested by this Shoreditch strip-bar doorman has given him more impressive tits than most of the performers inside. When he's resolutely jammed in front of the doorway no amount of baby oil or Bacardi Breezers will lubricate anybody's entrance.

TYPICAL LOCATION
Shoreditch High Street

USUALLY CARRIES
Drunk clients out the door

RARITY
2/10

SPOTTED

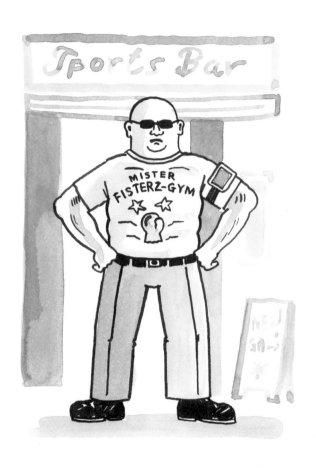

Strip Club Bouncer

TAI CHI BEGINNER

*After her third child in as many years this esteemed
curtain designer is so determined to retrieve her
pre-pregnancy figure that she visits the local park after
each school run and proceeds to wave her arms slowly in
the air as if beckoning a far-off tree.*

TYPICAL LOCATION
Clissold Park

USUALLY CARRIES
Repressed anger

RARITY
7/10

SPOTTED

◯

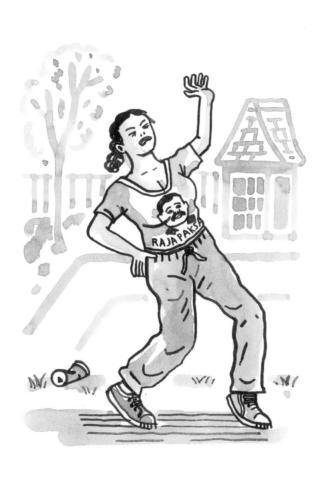

Tai Chi Beginner

TEENAGE JIHADIST

In a few months this pukka cockney will have saved up enough Tesco Clubcard points for a return flight to Islamabad. Pestering his Uncle Haq to reveal the secrets of making explosives from the contents of the septic tank will only result in a clip round the ear rather than the desired full martyrdom.

TYPICAL LOCATION
Whitechapel High Street

USUALLY CARRIES
Nike jogging trousers

RARITY
8/10

SPOTTED

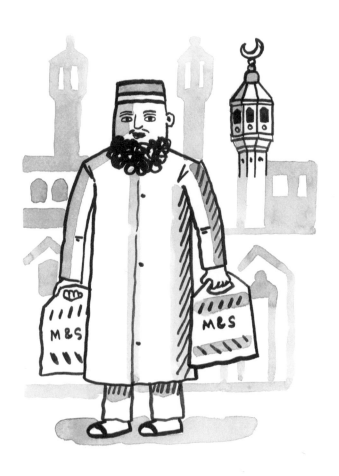

TEENAGE JIHADIST

TOO OLD FOR A SKATEBOARD

*If you are in your mid 40's and still love
ambient-deep-house-hard-biscuit then one way
to maintain age-busting credentials is to get your
street mutt to drag you round Victoria Park
on a long wheel-base vintage skateboard.
Go Daddy-Boy!*

TYPICAL LOCATION
Victoria Park

USUALLY CARRIES
Oversized headphones

RARITY
5/10

SPOTTED

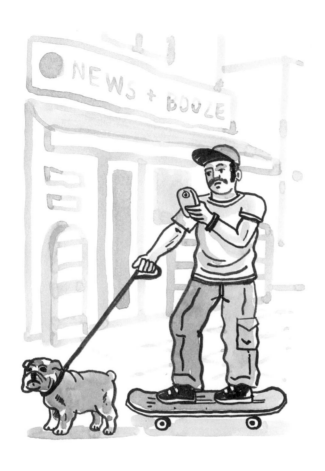

Too Old for a Skateboard

TRASHY WAITRESS

*It may be tempting to confuse the heavily bee-hived
caricature of the 1950's diner waitress for some kind
of desirable modern style icon – at least until you catch
a waft of her peculiar personal hygiene and a peek of
the 'West Ham 4 ever' inner-thigh tattoo.*

TYPICAL LOCATION
A Dalston bar

USUALLY CARRIES
A greasy tray

RARITY
3/10

SPOTTED

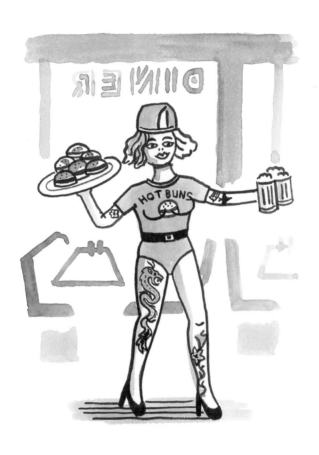

Trashy Waitress

V. IMPORTANT FASHION SHOOT

*There is no need to get a permit for a
fashion shoot in Hoxton as long as you are under 30,
are not working commercially and at least one person
is prepared to pose semi-naked as if suffering
from painful, trapped wind. Make sure to have
5 Japanese assistants to hold the reflector.*

TYPICAL LOCATION
Anywhere with urban degradation

USUALLY CARRIES
Green blusher

RARITY
4/10

SPOTTED

◯

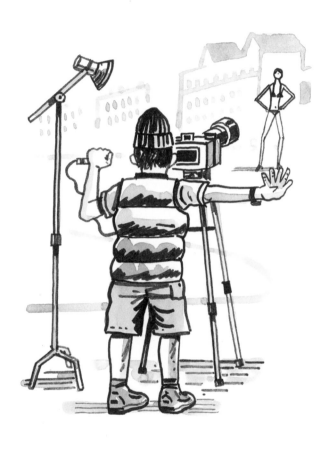

V.Important Fashion Shoot

VERY SILLY HAIRSTYLES

*This woman's barnet is so expressive that it
appears to be making a political statement.
However, since no-one speaks 'hair' it simply looks
like she has had a drunken encounter with
some pink dye and pipe-cleaners.*

TYPICAL LOCATION
Bethnal Green

USUALLY CARRIES
'Vice' magazine

RARITY
3/10

SPOTTED

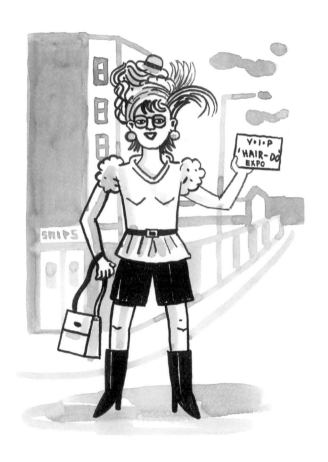

Very Silly Hairstyles

VERY VERY STUPID FASHIONS

*Treating fashion like a post-apocalyptic detritus-trawl
of mismatched rags, textiles and found objects,
this hyper-eclectic Shoreditch fashionista resembles
a demented extra in an 80's Blondie video.*

TYPICAL LOCATION
Trying to get into Shoreditch House

USUALLY CARRIES
Spare wig

RARITY
6/10

SPOTTED

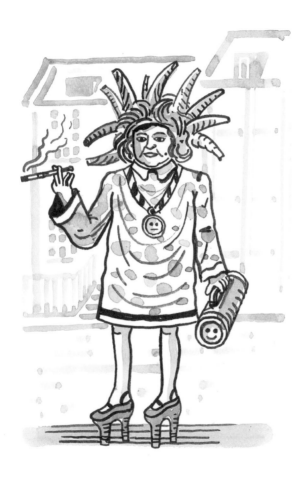

Very, Very, Stupid Fashions

WELL-OFF ART STUDENT

*Every Picasso canvas or Giacometti bronze that daddy
sells at auction leaves a little more gallery space to be
filled by his youngest prodigy – and also a bit more money
for her not to worry about ever pursuing a fruitful career.*

TYPICAL LOCATION
London Fields

USUALLY CARRIES
Vintage Chanel purse and cheap booze

RARITY
5/10

SPOTTED

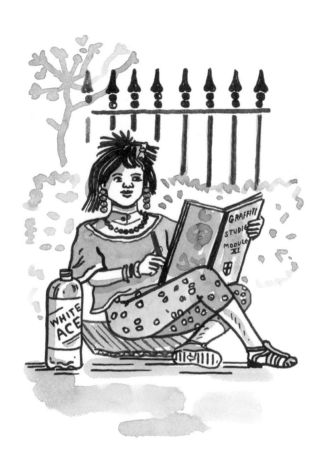

Well-off Art Student

HOW EAST LONDON ARE YOU?

Number of people spotted:

0–5
Awful.
You must live in Chelsea.

5–10
Very bad.
Go visit an obnoxious Shoreditch bar whilst wearing a onesie.

10–20
Fair.
You are entitled to burn BBQ patches in London Fields.

20–30
Good.
Are you in the book?

30–40
Excellent.
You are so native you probably moved here a year ago.

40–50
Incredible!
Open an art gallery. Employ staff without paying them.

If you have 40 or more good photos of the
fine people in this book then please send them to:

info@hoxtonminipress.com

If they are glorious then we will send you a
free poster print or a collector's edition of this book
and show them on our blog.

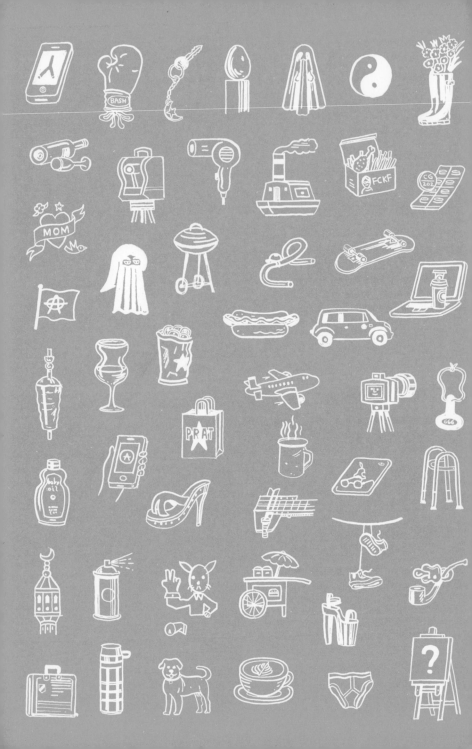